DATE DUE

The Library Store #47-0106

A Kid's Guide to Drawing™

How to Draw
Thanksgiving Symbols

Christine Webster

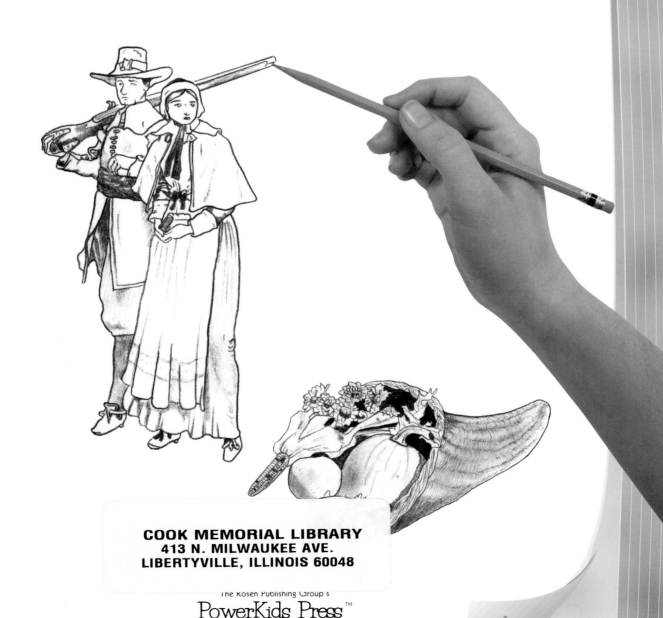

The Rosen Publishing Group's

PowerKids Press™

New York

To my grandmothers, Violet and Mildred

Published in 2005 by The Rosen Publishing Group, Inc.
29 East 21st Street, New York, NY 10010

First Edition

Editor: Orli Zuravicky
Book Design: Kim Sonsky
Layout Design: Mike Donnellan

Illustration Credits: Jamie Grecco
Photo Credits: pp. 6, 14, 16 © Bettmann/CORBIS; p/ 8 © Ed Young/CORBIS; p. 10 © North Wind Pictures; p. 12 © The Granger Collection; p. 18 © John Michael/International Stock; p. 20 © Royalty-Free/CORBIS.

Library of Congress Cataloging-in-Publication Data

Webster, Christine.
How to draw Thanksgiving symbols / Christine Webster.
 p. cm. — (A kid's guide to drawing)
Summary: Provides facts about symbols of Thanksgiving Day, as well as step-by-step instructions for drawing each one.
Includes bibliographical references and index.
ISBN 1-4042-2730-X (Library Binding)
1. Thanksgiving Day in art—Juvenile literature. 2. Drawing—Technique—Juvenile literature. [1. Thanksgiving Day in art. 2. Drawing—Technique.] I. Title. II. Series.
NC825.T48W43 2005
743'.893942649—dc22

2003020466

Manufactured in the United States of America

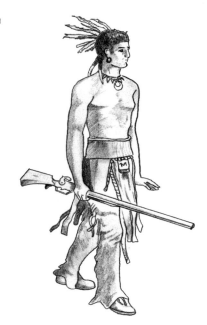

CONTENTS

Thanksgiving Symbols

On the fourth Thursday of every November, families throughout the United States come together for Thanksgiving. Thanksgiving marks the **celebration** of the colonists' first **harvest** in America, which the **Pilgrims** and their Native American friends shared nearly 400 years ago.

The Pilgrims were a group of people who left England in search of **religious** freedom. The king of England forced everyone to follow the laws of his church, but the Pilgrims refused. Because they were not allowed to practice their religion the way they wanted, the Pilgrims chose to leave the country. In 1620, they sailed across the Atlantic Ocean. After an unpleasant journey, they finally arrived in the Americas, also known as the New World. Their first winter in unknown lands was long and hard. After the first harvest, the Pilgrims gathered with their new Native American friends for a big feast. The Pilgrims gave thanks for their ability to **survive** the **hardships** of the New World, and for the **bounty** of crops that the Native Americans taught them to grow.

The feast of 1621 became known as the first Thanksgiving and marked the start of a **tradition**. In 1863, President Abraham Lincoln made Thanksgiving a national holiday. Americans celebrate Thanksgiving Day by giving thanks for their families, their homes, their culture, and their free country. They remember the Pilgrims' search for religious freedom, the history of their country, and the help they received from their Native American friends. They share huge feasts that include many foods eaten at the first Thanksgiving, such as roast turkey, cranberry sauce, and corn.

In this book you will learn all about the **symbols** of Thanksgiving. You will also learn how to draw these symbols. Take your time and read the instructions carefully. Follow the new steps marked in red. Use the list of drawing terms and shapes on page 22. Have fun!

The supplies you will need to draw each Thanksgiving symbol are:
- A sketch pad
- A number 2 pencil
- A pencil sharpener
- An eraser

The Mayflower

On September 16, 1620, the *Mayflower* ship set sail from Plymouth, England. The 180-ton (163-t) *Mayflower* was built out of lumber. **Tar** was used to **waterproof** the ship and handwoven cloths were used as sails. The trip took 66 days, which was longer than had been expected. Supplies ran out. Storms blew across the ocean, causing many of the ship's 102 passengers to become seasick. The salty seawater soaked their clothing and blankets. Dried meats and fruits, grains, flour, bad cheese, and hard biscuits were their main foods. Many people became sick from **malnutrition**, and one person died. Finally, on November 21, 1620, the *Mayflower* safely arrived in America. The *Mayflower* is an important symbol of Thanksgiving. For Americans, it stands for **courage**, freedom, and hope.

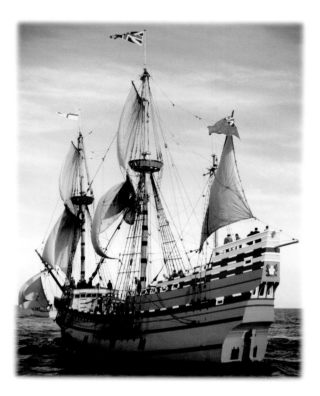

1

Draw three upside-down V shapes for the poles. Add a rectangular shape under the left pole. Draw a wavy line off the side of the shape, as shown, for the ship's front.

2

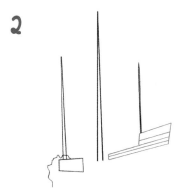

Draw four tilted rectangular shapes for the back of the ship. Notice that the two top shapes are shorter than the bottom two.

3

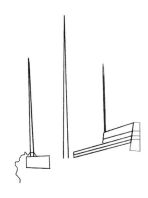

Add lines to the back of the ship to create another rectangular shape. It is wider at the bottom. Draw three horizontal lines inside the shape.

4

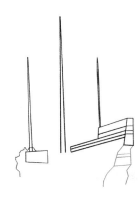

Finish the back of the ship by adding slanted and curved lines, as shown. Now draw three more horizontal lines inside the shape.

5

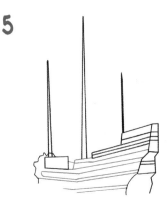

Draw horizontal and vertical lines as shown to create the ship's side. Notice that most of the lines slant a little bit.

6

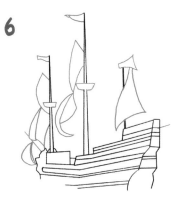

Add sails, flags, and crow's nests on the poles using curved and straight lines. At each end of the boat, draw one slanted line.

7

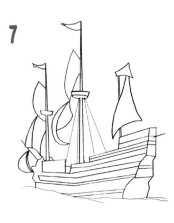

Draw the ropes using slanted lines. Draw lines at the bottom to create the surface of the ocean.

8

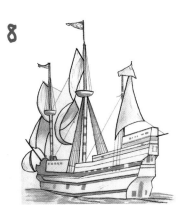

Add shading and finish as shown. Your ship is done!

Plymouth Rock

Plymouth Rock is a rock with the year 1620 **carved** on it. When the Pilgrims first landed in Plymouth Harbor on December 21, 1620, they might have set foot on this rock. Although the king of England had told them to settle in Virginia, they had trouble **navigating** the ship south. Instead, they docked much farther north and founded the colony of Plymouth, near Massachusetts.

On these shores, the Pilgrims wrote up an agreement, the Mayflower Compact, in which they promised to work together and make decisions as a community. This compact was the first written guide to governing in America. Today Plymouth Rock rests by the water in downtown Plymouth, Massachusetts. It **represents** the strength and bravery of the spirit of the American people.

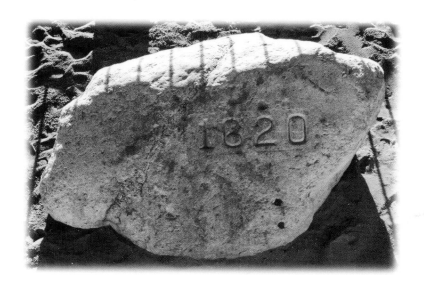

1

Start by drawing the shape of the rock.

2

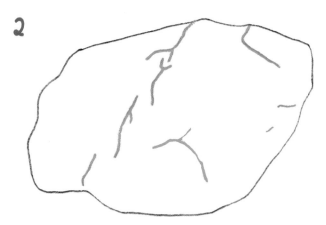

Use wavy lines to add cracks.

3

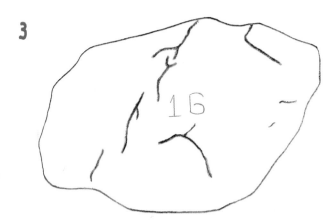

Add the number 16.

4

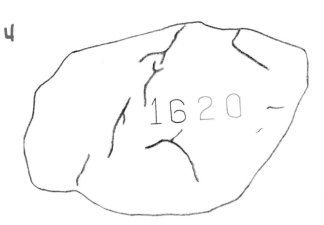

Now add the number 20 to finish the year 1620 carved into the stone.

5

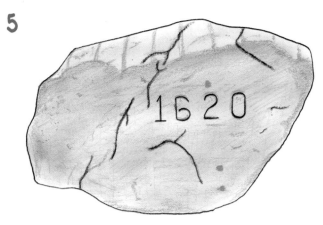

Add shading and finish as shown. Your Plymouth Rock looks real. Great job!

The Pilgrims

The Pilgrims' first winter in their new colony was hard. Almost one-half of the original settlers died from the cold weather, malnutrition, and sickness. To stay healthy, the Pilgrims dressed in clothes made from heavy fabric. Their clothing was sturdy, or strong, to withstand all of their hard work. The Pilgrims gathered wood, fetched water, hunted for food, built houses, and made everything by hand. The men often wore hats with big rims. Although rectangular **buckles** were not actually worn at the time, over the years hats with buckles have become part of the symbol of the Pilgrims. American children often celebrate Thanksgiving by making their own Pilgrim hats out of construction paper. They also dress up as Pilgrims and Native Americans in school and put on plays to honor the history of America.

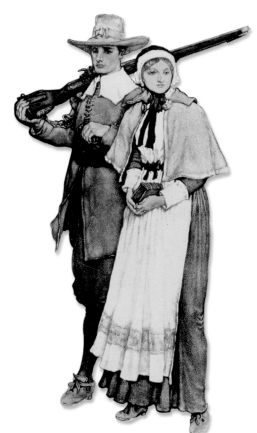

10

1 Draw two circles for the Pilgrims' heads. Draw a horizontal line on top of the left circle. Draw three lines on top of that line to create the shape of the man's hat.

5 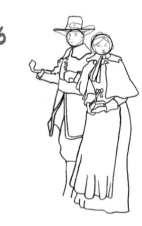 Erase any extra lines on the woman. Now use the guides to draw the man's clothing. Draw the man's collar and the buttons on his chest and arm.

2 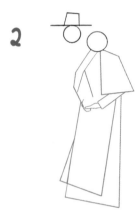 Using straight lines, draw the shape of the woman's dress, wrap, apron, and arms. Draw the shape of her hands. You will use these basic lines as guides.

6 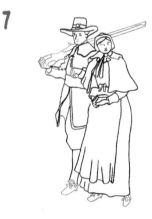 Erase any extra lines on the man. Use the circles to draw in the Pilgrims' faces, including eyebrows, eyes, noses, and mouths. Draw the man's hat and the woman's hairline and bonnet, or hat.

3 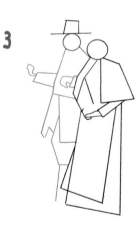 Draw the basic shape of the man's suit, arms, and leg with straight lines. Use curved and straight lines to create the shape of his hands. You will use these basic lines as guides.

7 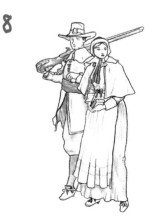 Erase extra lines and finish the man's hands. Add their shoes. Also add the gun in the man's left hand with straight and curved lines.

4 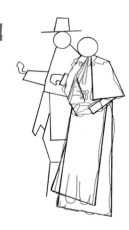 Using your guidelines to help you, create the woman's clothes. Draw the collar around her neck, the bow on her waist, the cuffs on her sleeves, and the book in her hands.

8 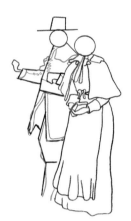 Add shading and finish as shown. You are done! Your Pilgrims look great!

Squanto

Squanto was a Native American from the Pawtuxet nation who lived near the Pilgrims in Massachusetts. He had spent some time in England and had learned to speak English, a skill that helped him **communicate** with the Pilgrims. Squanto and the Pilgrims became friends. He taught them to fish, plant corn, and gather berries and nuts. Without his help, the Pilgrims would have died of hunger. In 1621, Squanto acted as an **interpreter** between his chief, Massasoit, and Plymouth's governor, William Bradford. Squanto helped them create a **treaty**. It said that the Pilgrims and Native Americans would live together in peace. Without Squanto's help the Pilgrims would never have survived the first winter, and Americans today might not celebrate Thanksgiving at all!

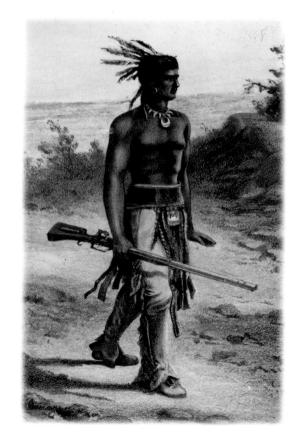

1

Start by drawing an oval for Squanto's head.

2

Use straight lines to draw the rough shape of Squanto's upper body, arms, and belt. Use curved and straight lines to draw the basic shape of his hands.

3

Use straight lines to draw the basic shape of his legs and feet and the cloth that is attached to his belt. Now draw the shape of his gun using straight lines.

4

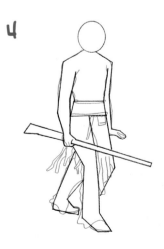

Draw the real shape of Squanto's hands, body, and clothing using your lines as a guide. Pay special attention to the pieces of his belt. Trace over the lines of his feet to create the bottoms of his pants and his shoes.

5

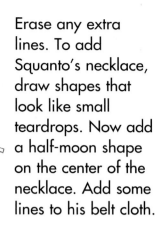

Erase any extra lines. To add Squanto's necklace, draw shapes that look like small teardrops. Now add a half-moon shape on the center of the necklace. Add some lines to his belt cloth.

6

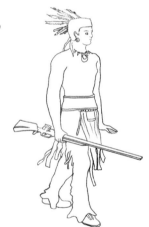

Draw Squanto's face. Include his eye and eyebrow, nose, mouth, ear, head, and hairline. Draw the feathers sticking out of his hair. Finish his gun and his shoelace.

7

Add lines for fingers. Erase any extra lines on his gun. Also erase the head guide lines.

8

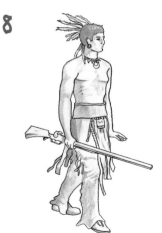

Add shading and finish as shown. Squanto is all ready to celebrate the first Thanksgiving. Great job!

The First Thanksgiving

The Pilgrims were grateful to the Native Americans for teaching them how to survive. The Pilgrims wanted to celebrate their harvest and show their thanks to the Native Americans. They decided to invite the local Native Americans to a harvest feast of thanks. The celebration included singing, dancing, and eating many different foods. This historical feast is known as the first Thanksgiving. Today Americans continue this tradition each November. During the Thanksgiving feast, families often take turns talking about why they are thankful. This tradition is often followed by praying or singing popular Thanksgiving songs such as "Over the River and Through the Woods." Many cities also hold parades for Thanksgiving. Families and friends gather either to take part in or just to watch the parades.

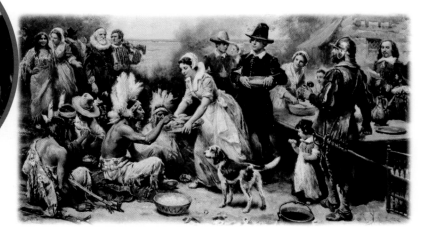

1 ◯ ◯

Draw two circles for the heads of the Native American and the Pilgrim woman. Notice that the right circle is higher up than the left circle.

5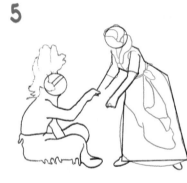

Erase any extra lines on the man. Shape the woman by tracing over the straight lines with curvier ones. Be sure to add her collar, apron, sleeves, hair, and bonnet.

2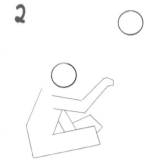

Draw the basic shape of the Native American's body. Use a curved line to create his hand.

6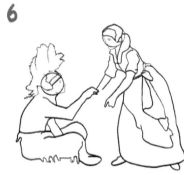

Erase extra lines on the woman. Draw faces on both figures.

3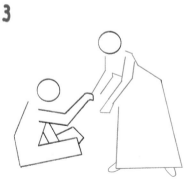

Use straight lines to draw the Pilgrim's upper body, arms, hand, and dress. Use two *U* shapes to draw her feet, as shown.

7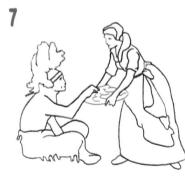

Erase the head circles and add the plate of food using curved lines.

4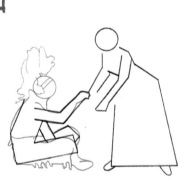

Trace over the shape of the Native American with curvier lines. Draw his neck and add wavy lines to his clothes. Draw his headband and the feathers that go on it.

8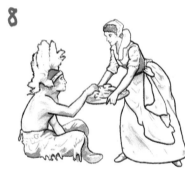

Add shading and finish the drawing as shown. Your picture of the first Thanksgiving looks great!

Indian Corn

The Native Americans taught the Pilgrims a lot about the New World. One lesson was how to plant and harvest corn. In the spring **kernels** of corn were planted deep in the ground. When the corn was harvested, it was eaten fresh, made into cornmeal, or dried and stored for the winter. Corn was harvested late in the autumn. Dried corn, known as Indian corn, came in different colors of red, yellow, blue, and black. This dried corn was also made into a food called hominy. First it was soaked in water for two days. After the kernels opened, the water was drained. Then the corn was cooked over a fire. In the fall, **stalks** of Indian corn decorate storefronts, Thanksgiving tables, and homes in honor of the Native Americans and the first Thanksgiving.

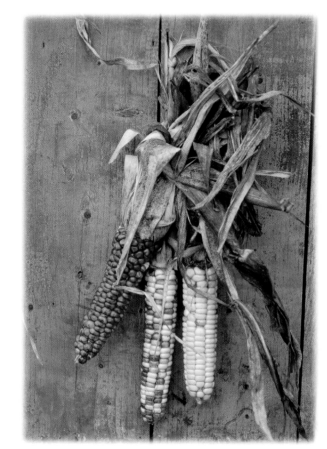

1 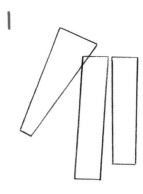 Draw three basic shapes for the three stalks of corn. Two of the shapes should be rectangular. The shape to the left will look more like a triangle with a flat point, as shown.

2 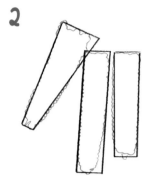 Inside the guides draw the ears of corn. Use wavy lines to create the outline of the kernels on the corn.

3 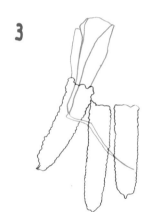 Erase the guides. Start drawing the first husk, or outer layer that covers the corn, with curvy lines.

4 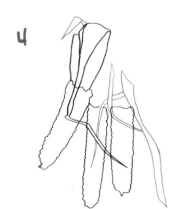 Draw some more of the husks with straight and curved lines. Notice how they are twisted and sticking out in all directions.

5 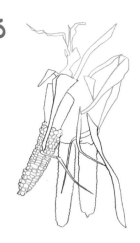 Erase any extra lines. Now draw in the kernels of the first piece of corn. They should be small, circular shapes. Add some more husks to the top of the corn, as shown.

6 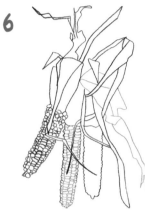 Draw kernels on the second piece of corn the way you did on the first. Add some more husks on the right side of the corn, as shown.

7 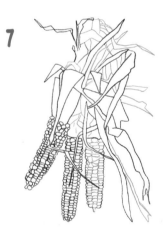 Draw in the kernels of the last piece of corn and finish the husks.

8 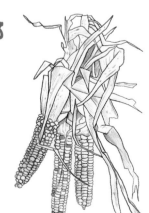 Add shading and you are all done. Great job!

17

The Cornucopia

The cornucopia, also known as the horn of plenty, is a horn-shaped basket that is filled with fruits and vegetables from the harvest. The cornucopia is a symbol of long life, success, and a plentiful harvest. The cornucopia is often made of **wicker** and shaped like a goat's horn. Filled with fruit and vegetables, it is used as a table decoration at the Thanksgiving feast.

One of the common vegetables found in the cornucopia is the pumpkin. Pumpkins were a big part of the Pilgrims' diet. The Native Americans taught the Pilgrims that pumpkins were healthy. They showed the Pilgrims how to grow them and make them into a tasty meal. Pumpkins were eaten as part of the main meal and the dessert. Today pumpkins are sweetened with sugar and served in pies with whipped cream on top.

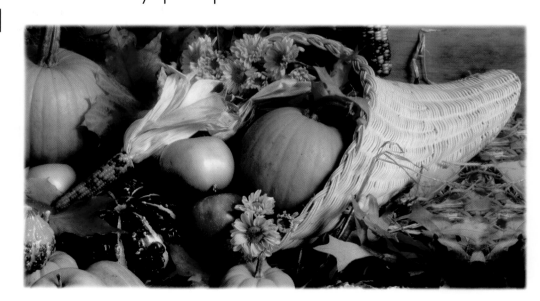

1

Start by drawing the rear of the cornucopia. The back should be round and it should curve upward.

2

Add the basic shape of the rim of the basket with two wavy lines. Notice how close together the lines are.

3

Use circular shapes and curved lines to add the pumpkin and two apples. Use curved lines to create the stem on the pumpkin.

4

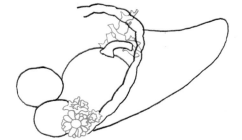

Add three flowers at the bottom of the basket with circles and small teardrop shapes. Add some leaves at the top of the cornucopia.

5

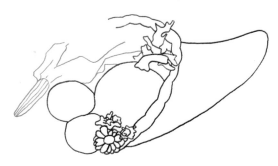

Erase any extra lines. Add the corn and the corn husk. Then add three wavy lines down the corn to use as a guide later when the kernels are added.

6

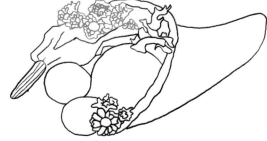

Add some more flowers to the basket, as shown.

7

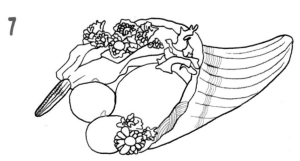

Draw the kernels in the corn using small curved lines. Add the weave, or pattern, of thread in the basket using curved lines. Add stems to the fruit.

8

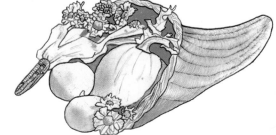

Finish drawing the kernels and weave. Add shading. Your cornucopia is ready for the Thanksgiving table!

The Thanksgiving Turkey

The turkey is the best-known Thanksgiving symbol. The tradition of eating turkey on Thanksgiving began at the first Thanksgiving in Plymouth. With the new skills they had learned from the Native Americans, the Pilgrims hunted and caught wild turkeys for the feast. The big, brown-feathered birds lived in the woods of eastern North America and were a popular and easy meal. Along with cooking turkey, the Pilgrims made a sauce out of small, red, sour berries, now known as cranberries. The Pilgrims named them **crane**-berries because the bent stalk on which they grew looked like the long neck of a crane. The cranberry sauce that the Pilgrims cooked still appears on Thanksgiving tables today. Both the turkey and the cranberry sauce were part of the first Thanksgiving and continue to be important symbols of the holiday today.

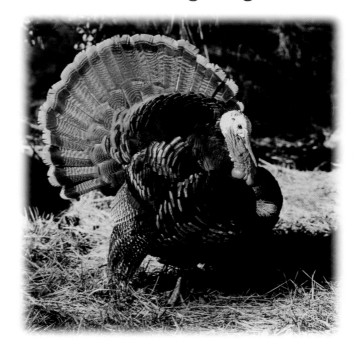

1
○ Draw an oval for the head of the turkey.

2

Add a big circle for the turkey's body. Notice that the head is positioned on the right side of the circle. Now draw the turkey's wattle, or red skin coming out of the neck, with several curved lines.

3
Draw two small straight lines coming out of the turkey's body, as shown. Draw a half circle, and connect the ends to the small lines. This will become the turkey's tail feathers.

4
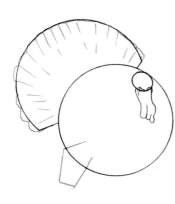
Use four straight lines to draw part of the turkey's wing on the bottom left side of the circle. Using curved and straight lines, draw feathers on the turkey's tail.

5
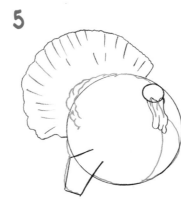
Erase the tail guide. Shape the body using curvier lines. Add two curved lines in front as shown. Use wavy lines on the top left side and wing to create more feathers. Add more lines to the turkey's wattle.

6
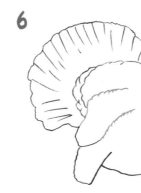
Erase extra lines. Add lines to the wing and the body for feathers.

7
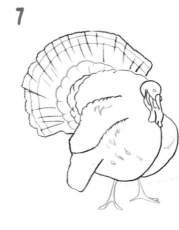
Draw two curved lines across the top of the tail and another wavy line for a back feather. Draw more wavy lines for feathers on the body. Draw two legs with V-shaped feet. Add the turkey's eye.

8
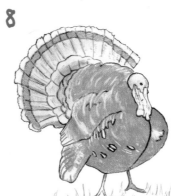
Add shading and finish the drawing as shown. Your Thanksgiving turkey looks great!

21

Drawing Terms

Here are some words and shapes you will need to draw the Thanksgiving symbols:

◯　circle

～　curved line

——　horizontal line

⬭　oval

▭　rectangle

🖌　shading

▢　square

△　triangle

|　vertical line

〜　wavy line

Glossary

bounty (BOWN-tee) A big supply of something.

buckles (BUH-kulz) Objects used to hold two ends of cloth together.

carved (KARVD) Cut into a shape.

celebration (seh-luh-BRAY-shun) Observance of an important occasion with special activities.

communicate (kuh-MYOO-nih-kayt) To share facts or feelings.

courage (KUR-ij) Bravery.

crane (KRAYN) A type of bird that is tall and has a long neck.

hardships (HARD-ships) Events or actions that cause suffering.

harvest (HAR-vist) A season's gathered crop.

interpreter (in-TER-prih-ter) Someone who helps people who speak different languages talk to each other.

kernels (KER-nulz) The soft inside parts of seeds.

malnutrition (mal-noo-TRIH-shun) A condition that results from not having enough of the right types of foods.

navigating (NA-vuh-gayt-ing) Steering a ship, an aircraft, or a rocket.

Pilgrims (PIL-grumz) The people who sailed on the *Mayflower* in 1620 from England to America in search of freedom to practice their own beliefs.

religious (ree-LIH-jus) Having to do with a faith, a system of beliefs.

represents (reh-prih-ZENTS) Stands for.

stalks (STOKS) Slender parts of the plant that support other parts.

survive (sur-VYV) To live longer than; to stay alive.

symbols (SIM-bulz) Objects or pictures that stand for something else.

tar (TAR) A sticky, dark liquid made from coal or bark, which hardens as it dries. It is used to waterproof houses and boats, and to pave roads.

tradition (truh-DIH-shun) A way of doing something that has been passed down over time.

treaty (TREE-tee) An official agreement, signed and agreed upon by each party.

waterproof (WAH-ter-proof) To make sure that water will not go through.

wicker (WIH-ker) A bendable plant or branch.

Index

Web Sites

Due to the changing nature of Internet links, PowerKids Press has developed an online list of Web sites related to the subject of this book. This site is updated regularly. Please use this link to access the list:
www.powerkidslinks.com/kgd/thanksym/